ABERYSTWYTH
HISTORY TOUR

First published 2016

Amberley Publishing
The Hill, Stroud,
Gloucestershire, GL5 4EP
www.amberley-books.com

Copyright © Will Troughton, 2016

The right of Will Troughton to be
identified as the Author of this work
has been asserted in accordance with
the Copyrights, Designs and Patents
Act 1988.

ISBN 978 1 4456 5697 7 (print)
ISBN 978 1 4456 5698 4 (ebook)

British Library Cataloguing in
Publication Data.
A catalogue record for this book is
available from the British Library.

Typesetting by Amberley Publishing.
Printed in Great Britain.

INTRODUCTION

Aberystwyth is the cultural capital of Wales, a tourist resort, market and university town. It has recently received yet another accolade, this time as the friendliest town in the UK whilst *The Independent* newspaper has dubbed Ceredigion the California of Wales. It is also my hometown and I am immensely proud of it. The intention of the book is to juxtapose old and new photos, creating a sense of what the town was like and how it has changed. By interweaving Aberystwyth trivia and historical information it is hoped that even seasoned scholars of the town's history will find something new.

Seven hundred years ago a defensive wall protected Aberystwyth. The walls fell into disrepair and were eventually robbed for building stone. Despite disappearing centuries ago these walls are responsible for the present-day street pattern and some of the street names including Great Darkgate Street from where the trail passes through Terrace Road (with a glimpse into North Parade), Alexandra Road and into the leafy tranquillity of Plascrug Avenue. A meander through the cemetery at the far end of Plascrug will tell you much of the history of the town. From the cemetery you will soon be in Llangawsai from where the road takes you into Llanbadarn Fawr.

Llanbadarn Fawr predates Aberystwyth as a settlement and was once an important ecclesiastical centre with a reputation for scholarship. The size of the church, far too large for a small village, hints at its importance. The church was once the haunt of Welsh poet and womaniser Dafydd Ap Gwilym (c.1320–c.1370). Before the development of Aberystwyth Llanbadarn held regular markets for buying and selling local produce. It could boast six public houses and was a meeting place for drovers walking cattle and sheep into England before the railways arrived. A plaque nearby details the exploits of Brigadier Lewis Pugh-Evans a local recipient of the Victoria Cross during the First World War. Turning right after the War Memorial, look out for

Ffordd y Sulien, named after Bishop Sulien who was closely associated with Llanbadarn during the eleventh century.

Pen Dinas is an Iron Age hill-fort which once supported a community of 300 people and is regarded as a marvel of Iron Age architecture and engineering. A number of phases of occupation have been identified by archaeologists. From the summit there is a 360 degree view taking in Cardigan Bay, the harbour, the town itself, the university campus and National Library, the Rheidol Valley, Plas Tanybwlch and the River Ystwyth.

A brisk walk over Trefechan Bridge, pausing to read the plaque and turning into South Road brings you into what was Aberystwyth's seafaring district. Many housenames recall ports of call favoured by local sailors and in some instances still the names of ships on which local men served. From here it is a short walk to the seafront, the Victorian splendour of pastel-coloured houses in South Marine Terrace and on to the War Memorial, ruined castle and ruined paddling pool. Rounding Castle Point brings into view the Old College, built as the Castle Hotel in the early 1860s but sold at a fraction of its value during a financial crisis a few years later and bought by far-sighted individuals to turn into a university.

The view to the north shows the fine sweep of the bay, dominated by Constitution Hill and the end of the tour. At the end of the promenade watch out for locals indulging in the age-old custom of kicking the bar. From here to the top of Constitution Hill is an ascent of 425 feet (129.5 metres) to the summit of Constitution Hill. All there is left to do is make your way to the restaurant on the top, find a table and enjoy the view of the cultural capital of Wales.

W. Troughton
March 2016

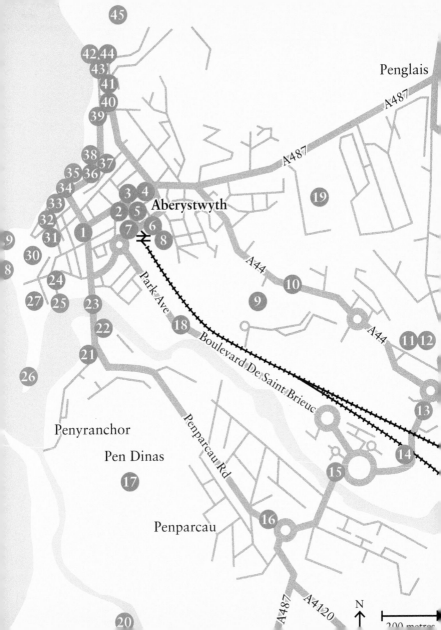

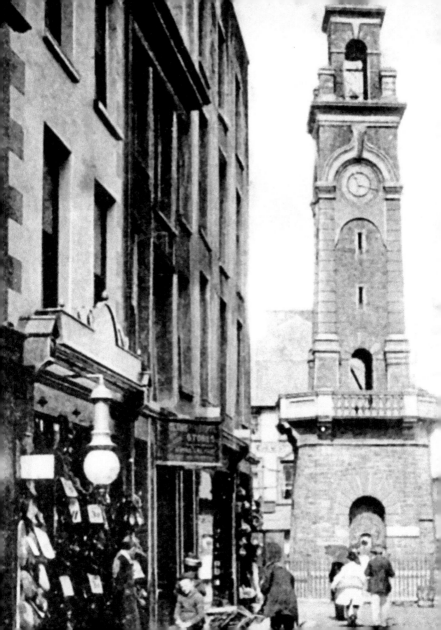

1. TOWN CLOCK

Aberystwyth's town clock was demolished among howls of protest in 1957. Eventually, to celebrate the dawn of a new millennium the present clock tower was built in 2000. The original water fountain, presented by a local minister hoping to promote Temperance, has been reinstated.

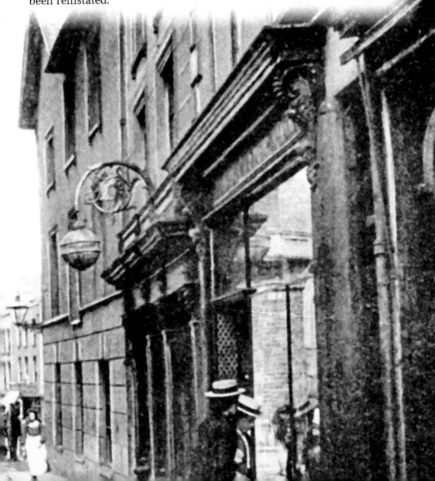

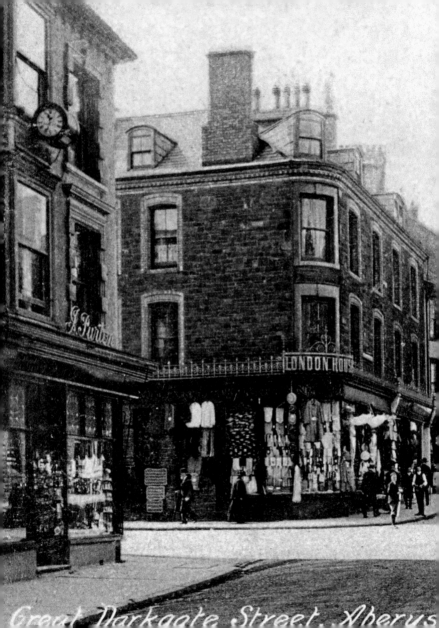

Great Darkgate Street, Aberus

2. GREAT DARKGATE STREET

When Aberystwyth had a town wall (about the time Columbus landed in America) one of the main gates into the town stood at the bottom of this street, hence its name. All trace of the town walls disappeared centuries ago, but the medieval street pattern left behind has remained.

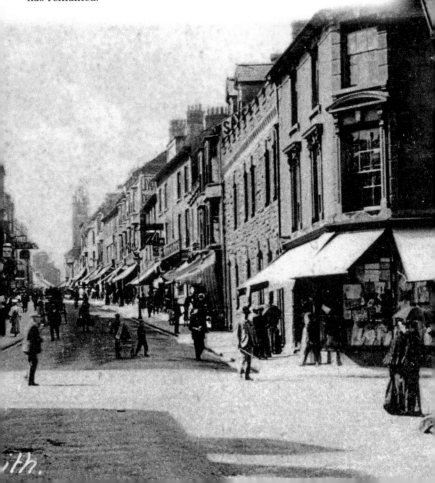

3. FROM NORTH PARADE, LOOKING UP

Barclays Bank has been in the same building since 1877, although it has grown through purchase of the adjacent Caprice Restaurant. Other businesses in this part of town in the 1930s included the County & Boro' stores and H. Hughes, butcher.

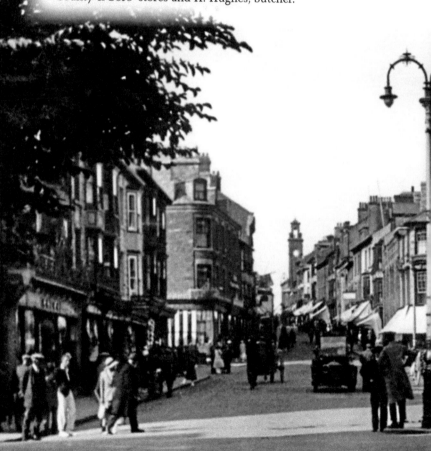

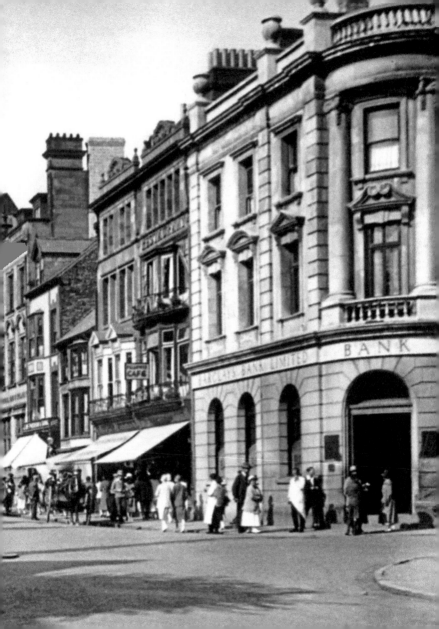

4. NORTH PARADE LOOKING DOWN

North Parade got its name from being used as a parade ground by the local (unkempt and unshaven) militia. However, it had been built on by the early 1830s and was favoured by the wealthier inhabitants of the town. A century ago the centre of North Parade was where landaus, horse-drawn four-wheel carriages, could be hired, akin to taxis of today.

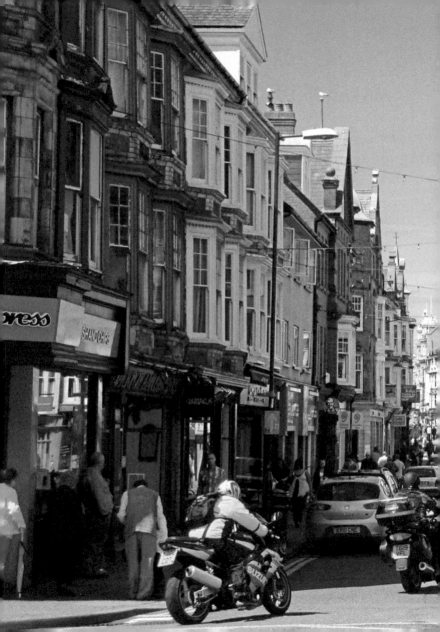

5. TERRACE ROAD LOOKING
TOWARDS THE SEA

Being the main thoroughfare from the railway station to the seafront, Terrace Road was an immensely popular location for shops. In 1900 Terrace Road boasted numerous refreshment rooms, hairdressers, fancy goods' shops, drapers and confectioners. The Terminus Hotel, on the right (now renamed the Vale of Rheidol), was the first public house in Aberystwyth to have an autopiano, a forerunner of the jukebox. The device was derided by the editor of the local newspaper as a complete waste of money.

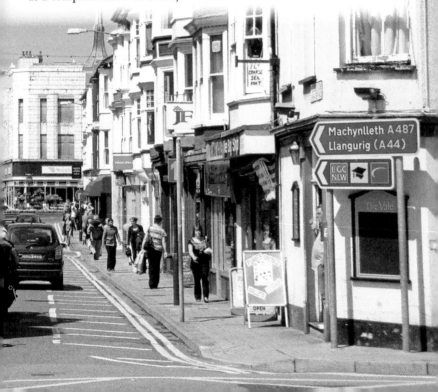

6. ALEXANDRA ROAD

Alexandra Road was previously known as Lewis Terrace but the name was changed in honour of Princess Alexandra who visited the town in 1896. On the left part of the frontage of the original railway station can be seen.

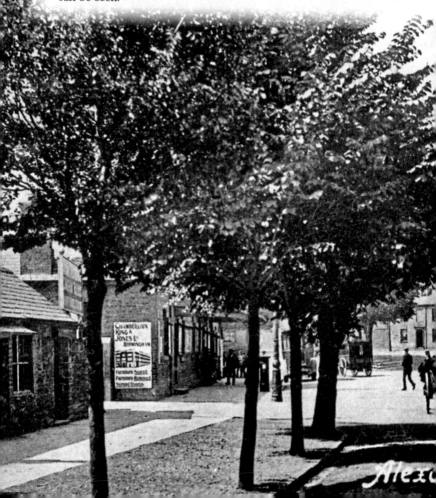

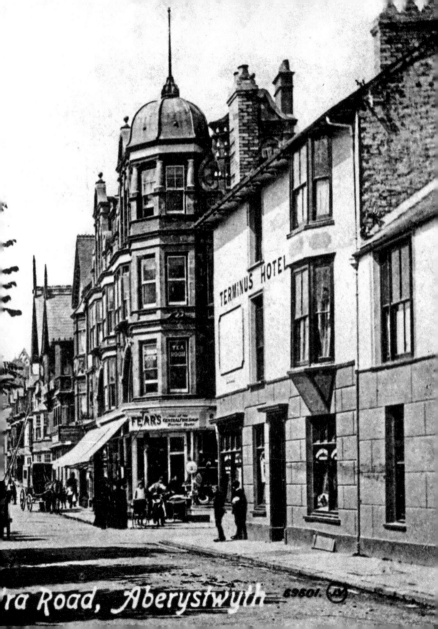

TERMINUS HOTEL

FEAR'S

TEA ROOM

ra Road, Aberystwyth 59501.

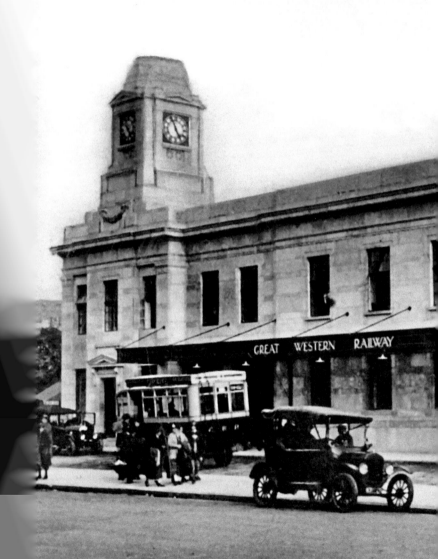

Railway Station, Aberystwyth.

7. RAILWAY STATION

In 1922 the Cambrian Railways amalgamated with the Great Western Railway. The following year the new company wasted no time in spending £94,500 on a new and much grander neo-Georgian station. On the first floor was a large assembly room that served as a restaurant. The old station stood directly in front of the new and was demolished on completion of its successor to provide the driveway in the foreground.

8. PLASCRUG AVENUE

Plascrug Avenue is named after the castle that once stood on the site of Plascrug Primary School. The avenue was laid out specifically for the use of pedestrians and cyclists. It is now the venue for the town's Park Run every Saturday morning.

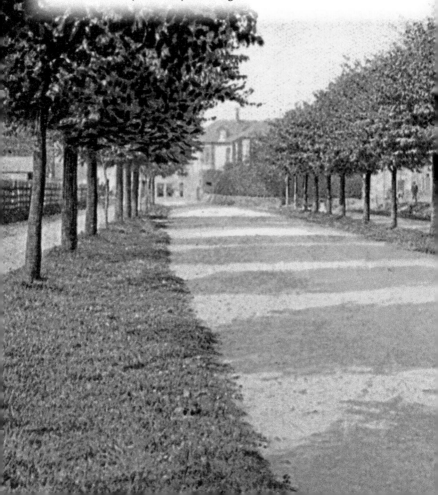

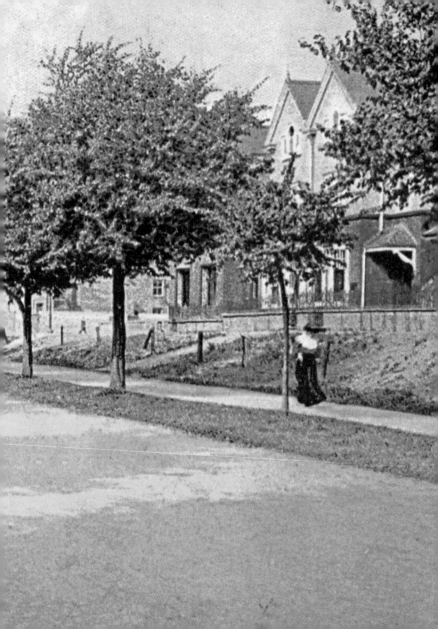

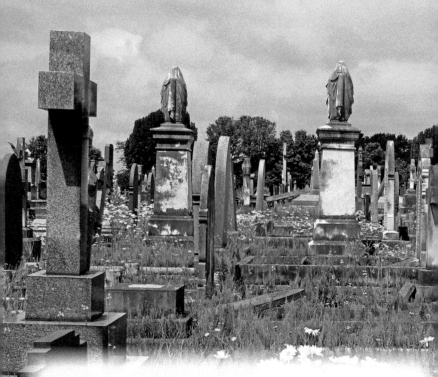

9. ABERYSTWYTH CEMETERY

The town cemetery contains headstones from three centuries and is a history lesson in itself. Some memorials record Victorian sailors lost at sea, others our dead from two world wars. Most commemorate the inhabitants of the town and their numerous vocations, whether publican, platelayer, parson or plumber.

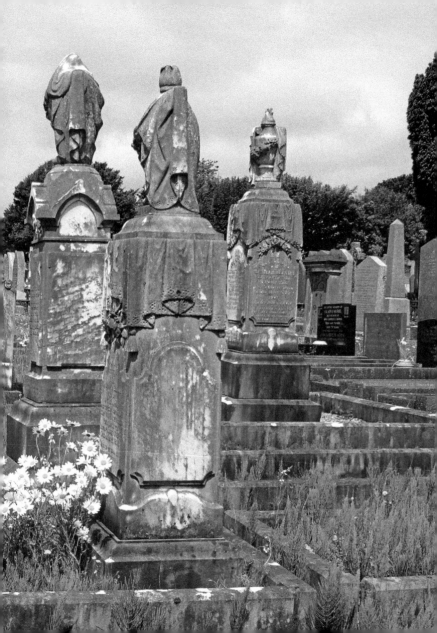

Aberystwyth. - Thatched Cottage.

10. LLANGAWSAI

Llangawsai, a corruption of an older name Llain-y-gawsai lies between Aberystwyth and Llanbadarn Fawr. The thatched roofs may have gone but the cottages are still there. When walking past the cottages note the postbox opposite, now painted black, a reminder that Llangawsai once had its own post office

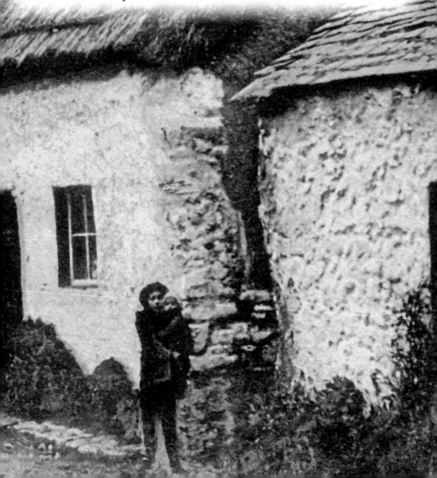

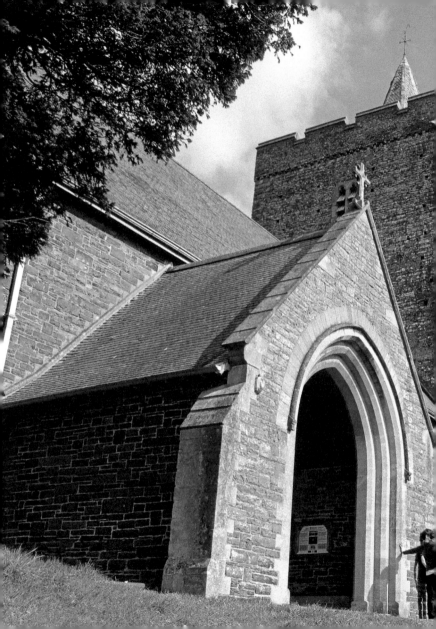

11. LLANBADARN FAWR CHURCH

Young worshippers enjoy the spring sunshine and a chat outside Llanbadarn Fawr Church. The first church was built in the sixth century, the present church dating back a mere 800 years or so. It withstood the depredations of the Vikings and is mentioned in the verses of the fourteenth-century poet Dafydd Ap Gwilym. However it was not religious fervour that brought Dafydd to Llanbadarn but pursuit of the local young ladies.

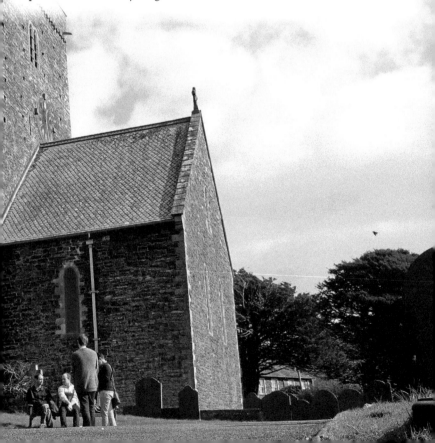

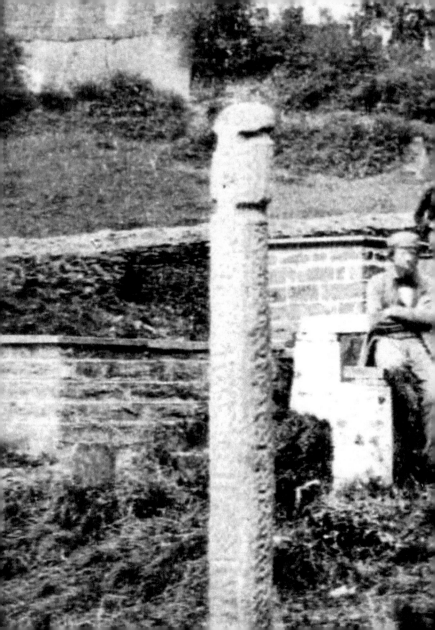

12. LLANBADARN FAWR, CELTIC CROSSES

These two Celtic crosses stood outside Llanbadarn church for centuries. They are thought to date from the tenth and twelfth centuries, the smaller stone being the older. Both now form part of an informative display inside the church.

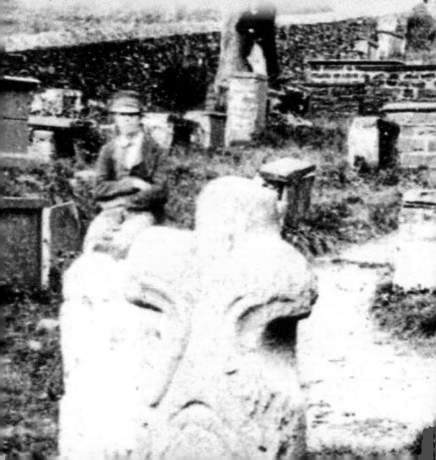

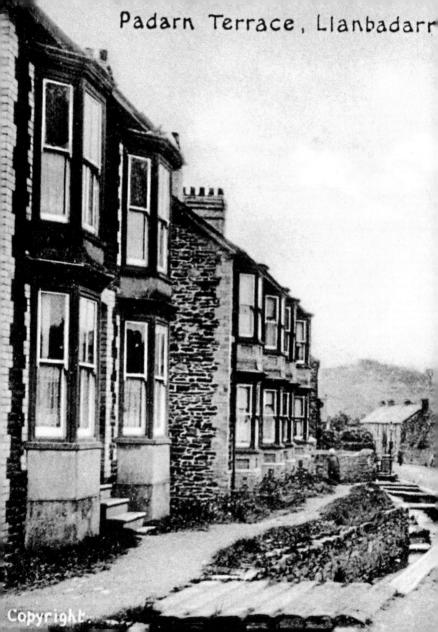

Padarn Terrace, Llanbadarr

13. LLANBADARN FAWR, PADARN TERRACE

Llanbadarn Fawr once had far more taverns than the two in the village today. The nearest building on the right was one such establishment, known as Ty Mawr. Note the brook running in front of the houses (and now covered over).

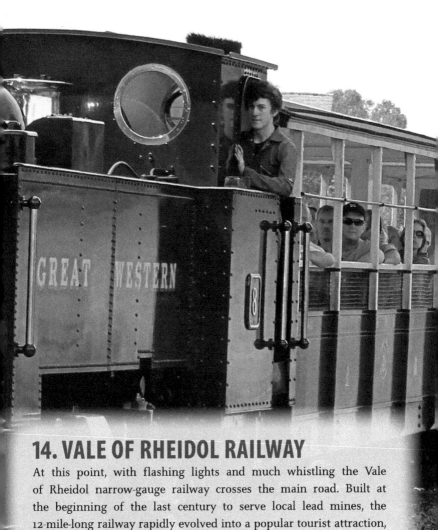

14. VALE OF RHEIDOL RAILWAY

At this point, with flashing lights and much whistling the Vale of Rheidol narrow-gauge railway crosses the main road. Built at the beginning of the last century to serve local lead mines, the 12-mile-long railway rapidly evolved into a popular tourist attraction, a position it retains to this day.

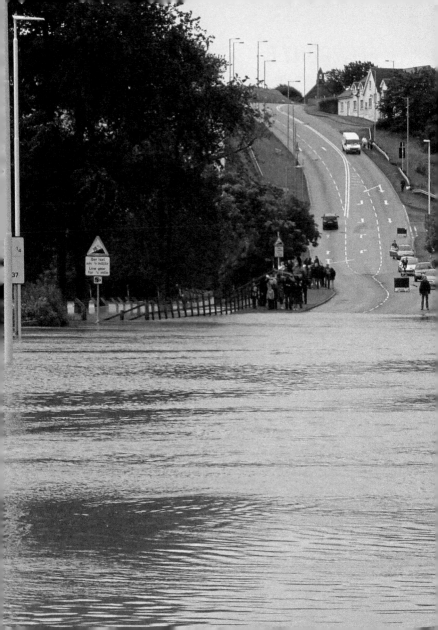

15. PENYBONT BRIDGE

Penybont bridge over the River Rheidol connects Llanbadarn Fawr and Penparcau. In 2014 floods, the like of which had not been seen for a century, inundated the area. The playing fields to the left of the bridge are noteworthy as the place where the author's unimpressive rugby career came to an uncomfortable end.

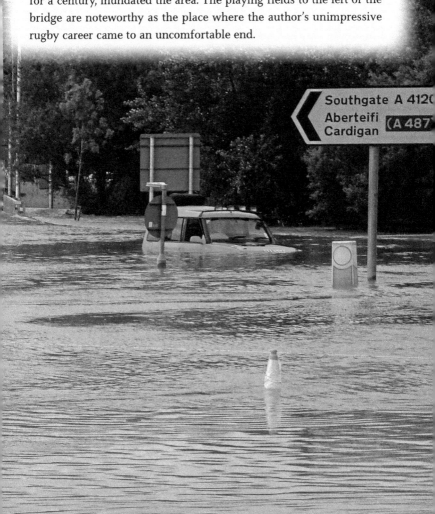

16. PENPARCAU

When the unknown photographer who took this image sarcastically called it 'City Road' he had no idea that a century later Penparcau would have a population of over 3,000 souls, a post office, two small supermarkets, a garage, holiday park, hotel and, until recently, two fish and chip shops. At the time the photograph was taken Penparcau was a sleepy village of small whitewashed cottages with no sign of the housing estates that were to follow.

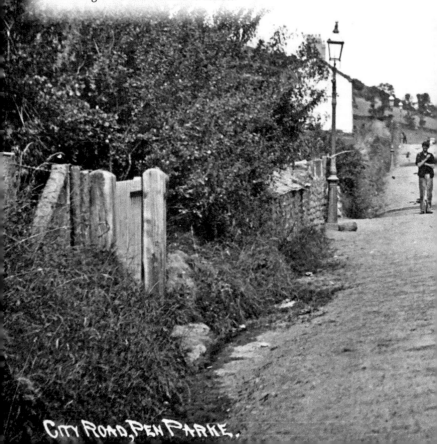

CITY ROAD, PEN PARKE.

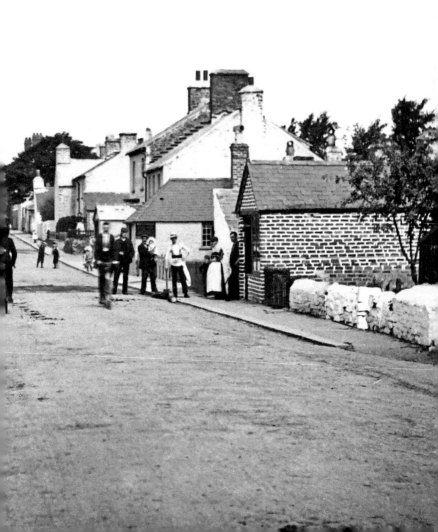

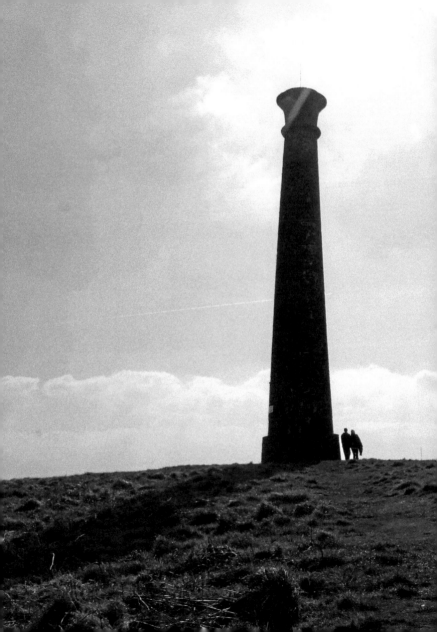

17. PEN DINAS MONUMENT

The monument on the top of Pen Dinas is in the form of an upturned cannon. It was erected circa 1858 as a memorial to the Duke of Wellington. Standing nearly 60 feet tall, it was erected by Major Richards of nearby Bryneithin Hall. Pen Dinas itself is an Iron Age hillfort, the ramparts of which are clearly visible. It is thought to have been inhabited for around 300 years, up until around the time the Romans invaded Britain.

18. VIEW FROM PEN DINAS

Looking inland there has been much development in the floodplain of the River Rheidol while a number of landmarks have disappeared, most notably the railway line to Carmarthen, though there are moves afoot to reopen it.

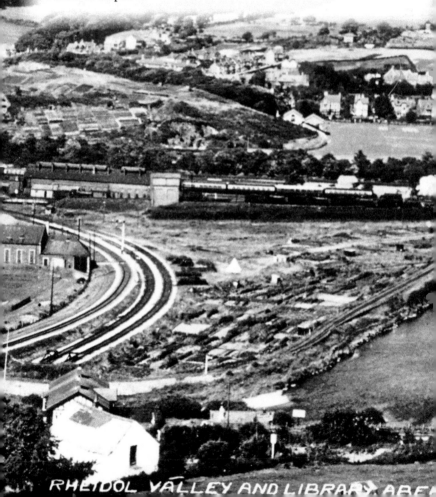

RHEIDOL VALLEY AND LIBRARY ARE

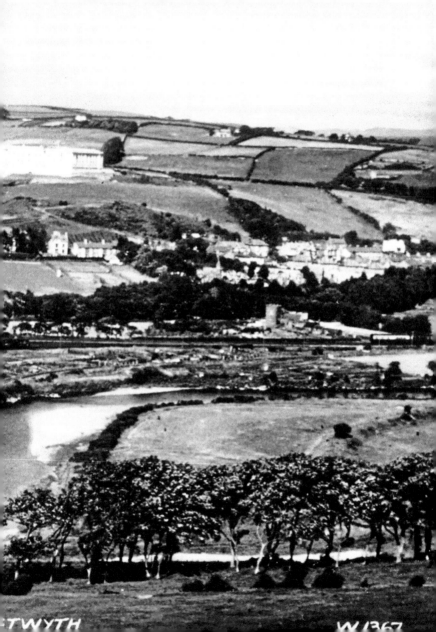

TWYTH W.1367

19. NATIONAL LIBRARY FROM PEN DINAS

The foundation stone of the National Library of Wales was laid in 1911. Five years later the library opened to the public. Today it contains 6 million books, a million photographs, a million maps, 60,000 works of art and 25,000 manuscripts, not to mention the numerous archives and thousands of hours of audio-visual material. Access is free and regular tours are available. In addition the library has its own restaurant and shop

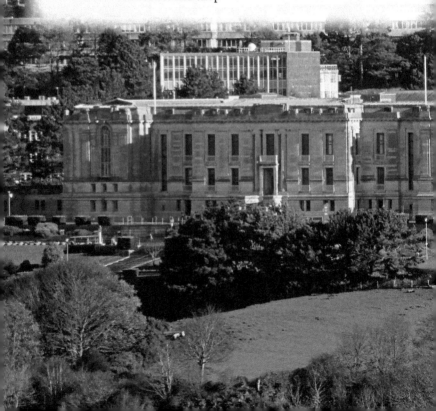

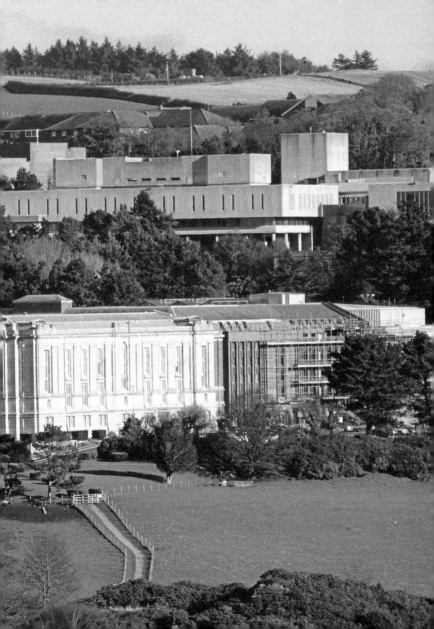

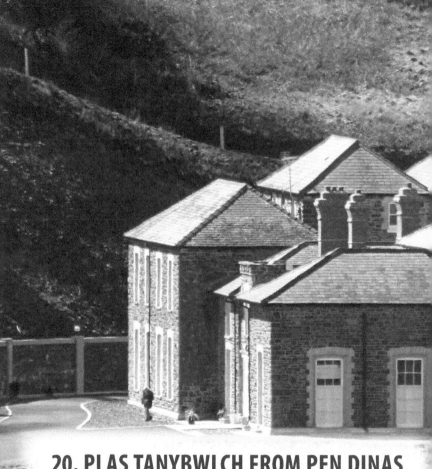

20. PLAS TANYBWLCH FROM PEN DINAS

Plas Tanybwlch dates back to 1790. Since being built it has been the home of Lord Ystwyth (1840–1935), an isolation hospital, catering department of the local Further Education College, before being recently turned into luxury apartments, the home of Uli Jon Roth, formerly guitarist with the German heavy metal band The Scorpions.

21. TREFECHAN

Looking to the north affords a view of the harbour and in the foreground Trefechan, once the hub of Aberystwyth's ship-repairing businesses – sail-makers, blacksmiths, rope-makers and coopers being among some of the professions.

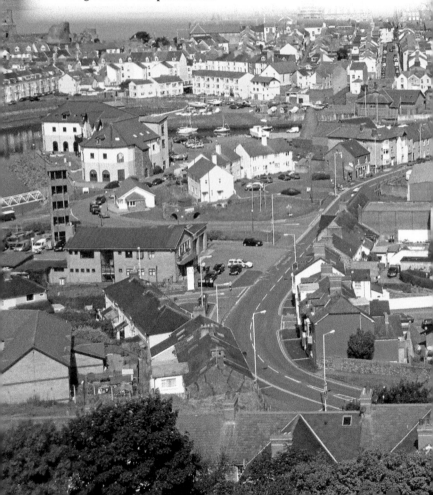

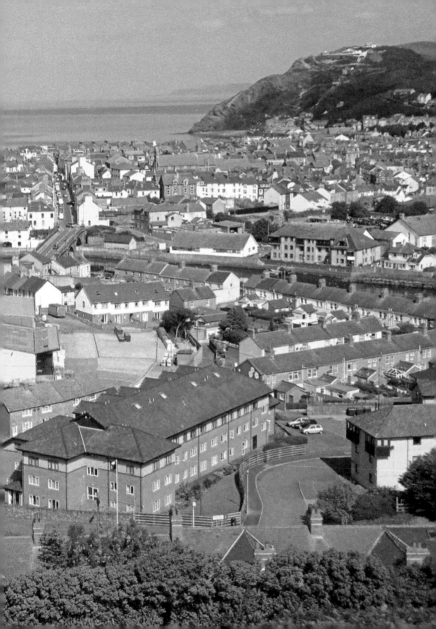

BEER IS BEST

Especially when it is

ROBERTS'S

INDIA PALE ALE

OR

BROWN ALE

THESE BRILLIANT APPETISING AND NOURISHING BEERS ARE AVAILABLE IN

22. ROBERTS'S BREWERY LABEL

The car park next to the Fountain Inn was once the site of Roberts's Brewery. David Roberts started brewing beer in 1844 and passed the business on to his sons. By the time the company was taken over in 1960, they owned 117 tied houses throughout mid Wales.

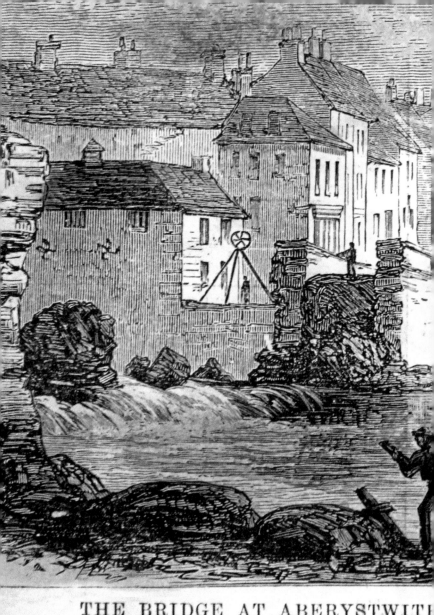

THE BRIDGE AT ABERYSTWITH

23. TREFECHAN BRIDGE

The present-day Trefechan bridge was built after its predecessor was washed away in floods in 1885. A plaque on the bridge commemorates the first demonstration in support of the Welsh language held by Cymdeithas Yr Iaith Gymraeg (The Welsh Language Society) on the bridge on 2 February 1963.

)ESTROYED BY THE FLOOD.

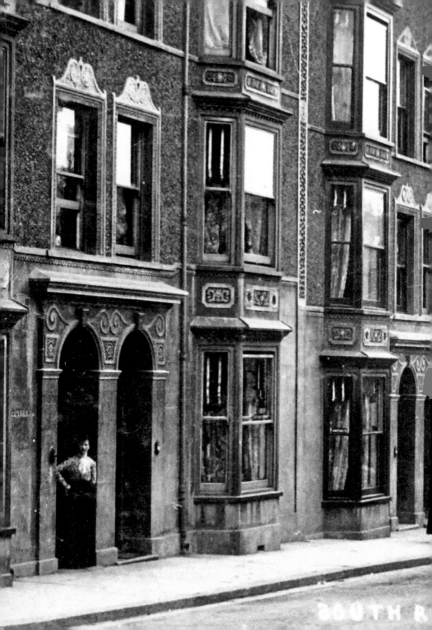

24. SOUTH ROAD

Around 1905 South Road had recently replaced Shipbuilders Row as the street name and the houses on the left were all newly built. The house on the extreme left has hats on display in the window and is probably the home of Miss Griffiths, a milliner and dressmaker. Many of the other houses offered apartments to visitors. Today most of the houses in this row are student houses and the corner shop in the distance has long gone.

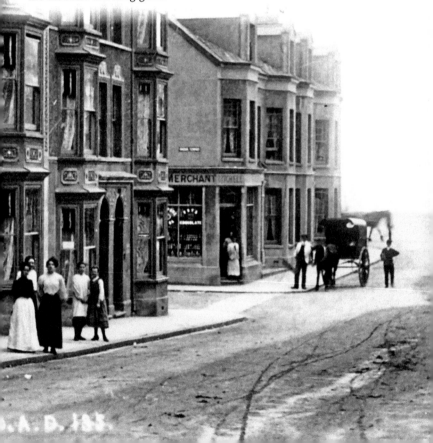

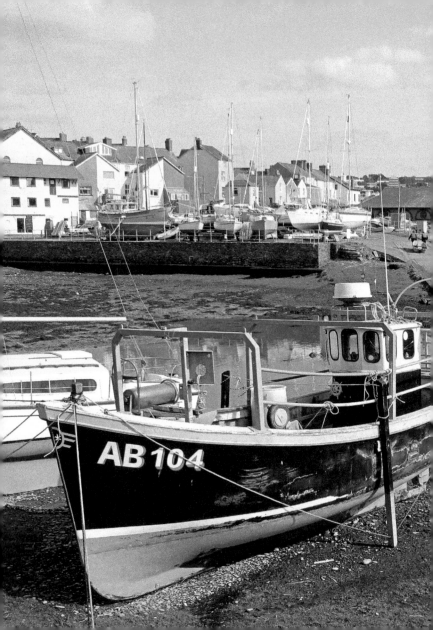

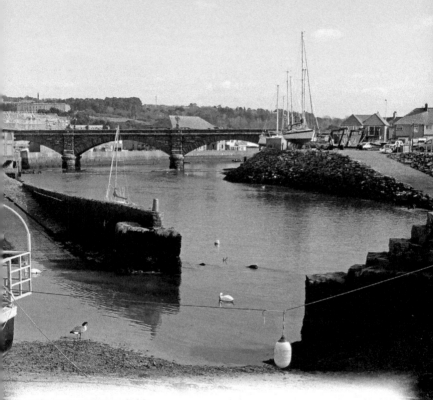

25. Y GEULAN

AB 104 *Boy Scott* guards the entrance to the small inner harbour, once the area known as Y Geulan. This was the area used through much of the nineteenth century for shipbuilding. Many fine sailing ships were built in Aberystwyth and went on to trade all over the world.

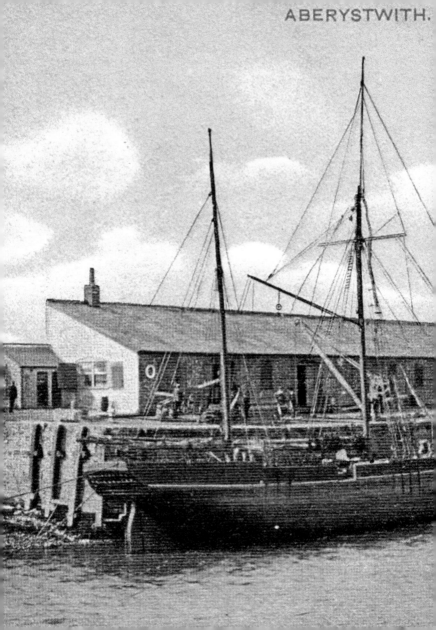

26. THE HARBOUR

A crowded quayside in November 1905. On the left is the *William & Mary* from Bridgewater that arrived with building supplies; nestled against the quay is the *Countess of Lisburne* and outside her is the steamer *Mayflower of Cardigan*, sheltering from a recent storm. No cargo vessel has used the harbour since 1987 and the quayside is now used by a number of local fishing boats such as *Quaker* and *Pen Dinas*. This part of the quay is also home to the town's highly successful rowing club.

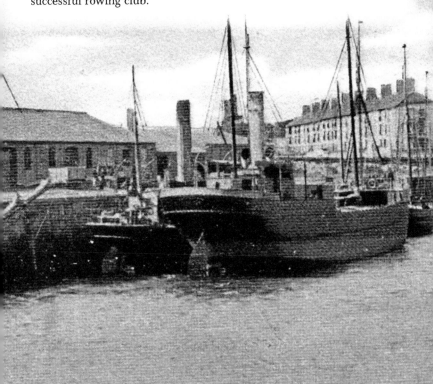

27. SOUTH MARINE TERRACE

South Marine Terrace occupies the site of a former timber yard which supplied the local shipbuilders with timber from North America and Scandinavia. Today the Terrace has a number of fine guest houses with sea views and no excuse not to go for a bracing walk before breakfast.

28. OLD PADDLING POOL

In October 1915 Councillor Robert Doughton proposed the idea of building a marine lake near Castle Point. The idea was duly taken up and proved popular until severely damaged by the storm of January 1938.

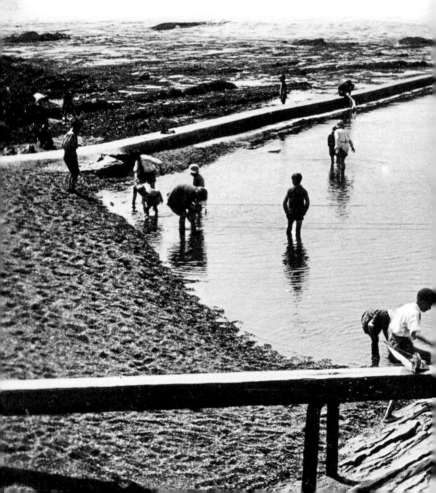

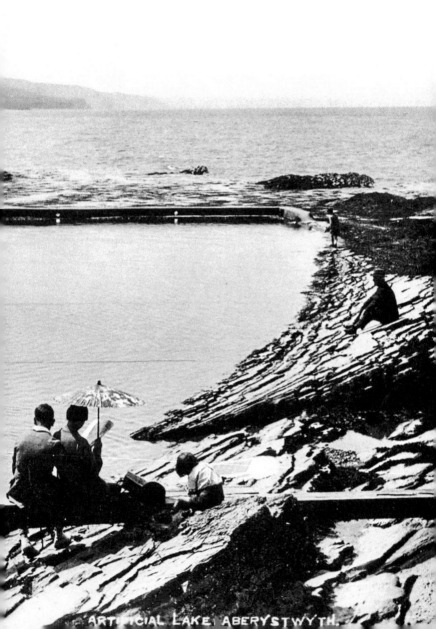

ARTIFICIAL LAKE, ABERYSTWYTH.

29. WAR MEMORIAL

Designed by Professor Mario Rutelli, the town's war memorial records the names of the fallen heroes from two world wars. The figure on the top represents Winged Victory, while that at the base (a bold design for nonconformist Aberystwyth of the time – see back cover) represents Humanity emerging from the effects of war.

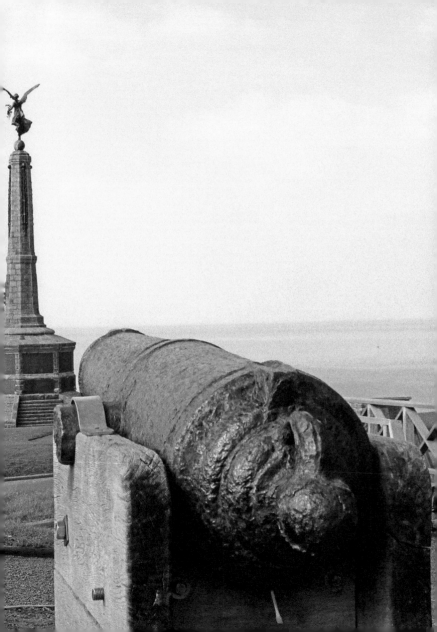

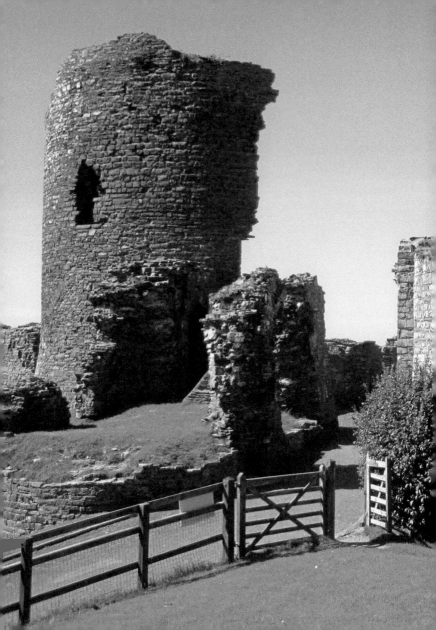

30. CASTLE RUINS

Aberystwyth Castle was built over a twelve-year period starting in 1277. It was captured in 1282, 1404 (by Owain Glyndwr), 1408, and 1646. It withstood sieges in 1282 and 1294 and was largely destroyed in 1649. The two ruined towers on the left once guarded the main entrance, that on the extreme right another smaller entrance.

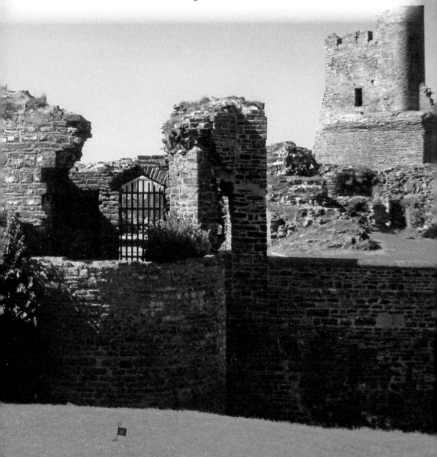

31. ST MICHAEL'S CHURCH

The present-day St Michael's and All Angels Parish Church dates from 1890. It replaced a smaller inferior building, the vestry of which still be seen adjacent to the present-day playground. The original plan for St Michael's included a spire atop the tower but this was never completed. The adjacent churchyard was landscaped in 1973 by which time a century had elapsed since the last burial.

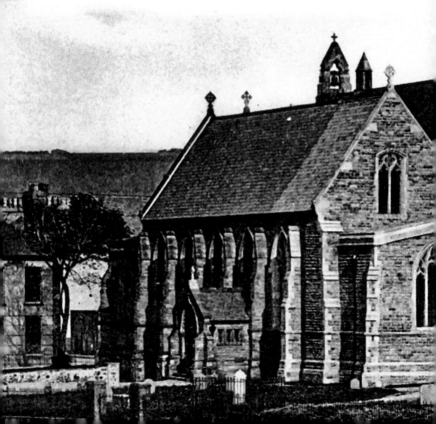

32. OLD COLLEGE

For the first forty years of its existence the university was very literally 'The College by the Sea', a proximity that must have given those students not from coastal communities some heart-stopping moments. The extension of the promenade from the pier past the university and around Castle Point to South Marine Terrace took place from 1901–03 at a cost of £16,000. The difference in architectural styles between the original parts of the Old College and the portion rebuilt after the fire of 1885 (on the right) can be seen.

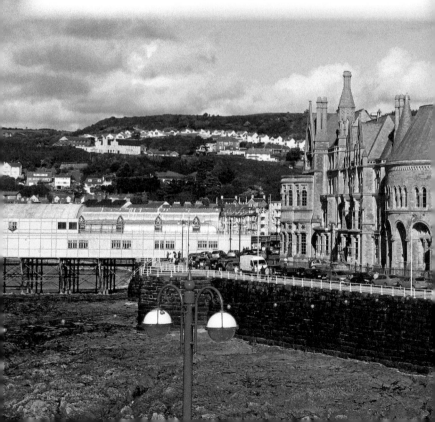

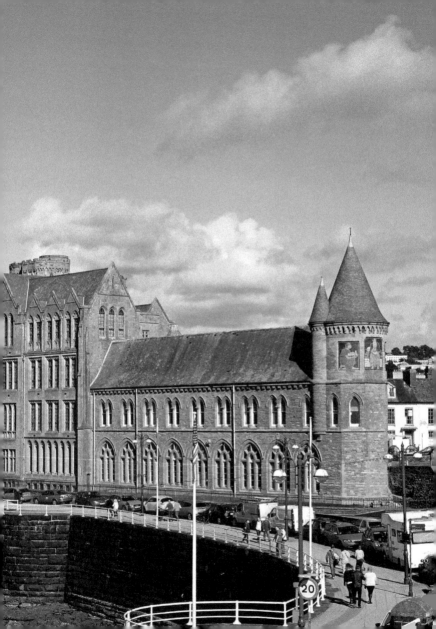

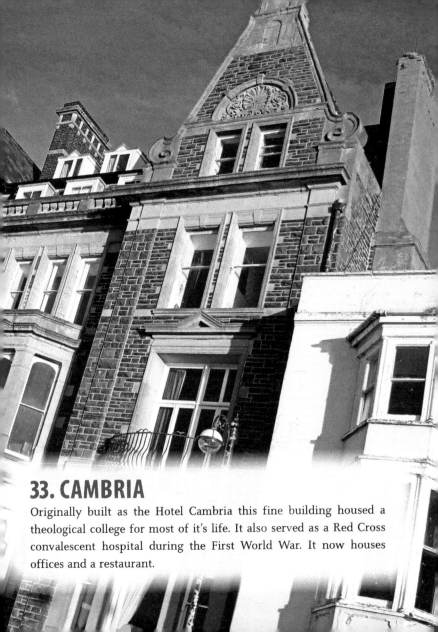

33. CAMBRIA

Originally built as the Hotel Cambria this fine building housed a theological college for most of it's life. It also served as a Red Cross convalescent hospital during the First World War. It now houses offices and a restaurant.

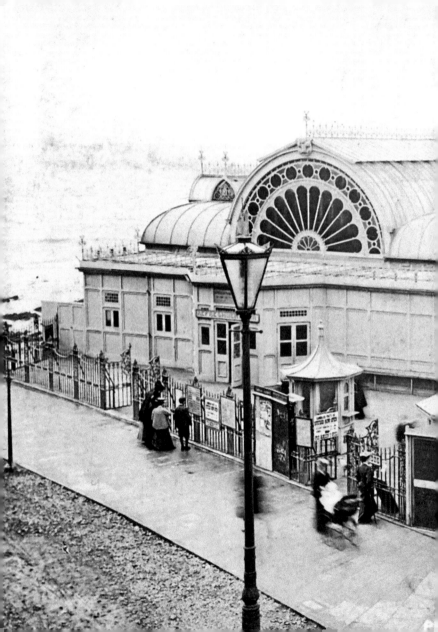

34. PIER

The first purpose-built pleasure pier in Wales opened in 1865, though the Royal Pier Pavilion (capacity 3,000) was not added until 1896. A hundred years ago the pier offered a variety of entertainments such as minstrel troupes, phrenologists, recitals, a bookstall and refreshments. A band played daily at the small pavilion at the end of the pier. Today the pier houses a nightclub, bar, brasserie, snooker hall, DVD rental shop, amusement arcade and Don Gelato ice-cream kiosk.

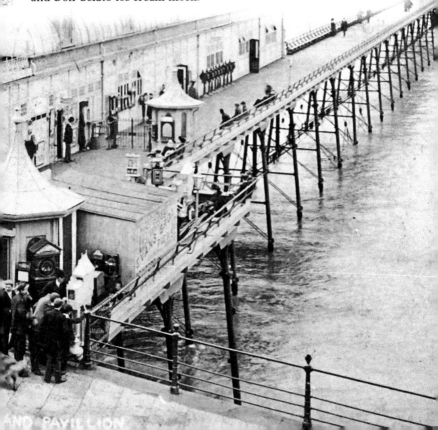

AND PAVILLION

35. VIEW LOOKING NORTH

Looking north towards Constitution Hill showing the new bandstand, which opened in 2016. The wooden jetty in the foreground was once used by pleasure boats offering trips in the bay.

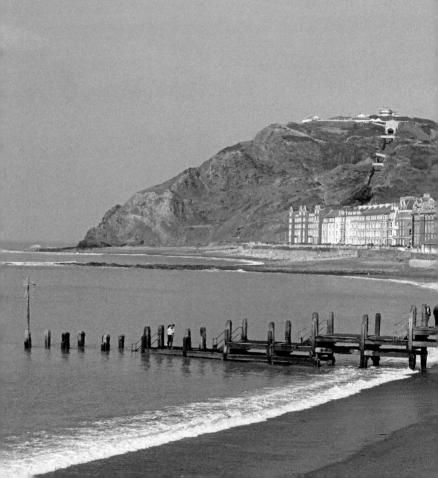

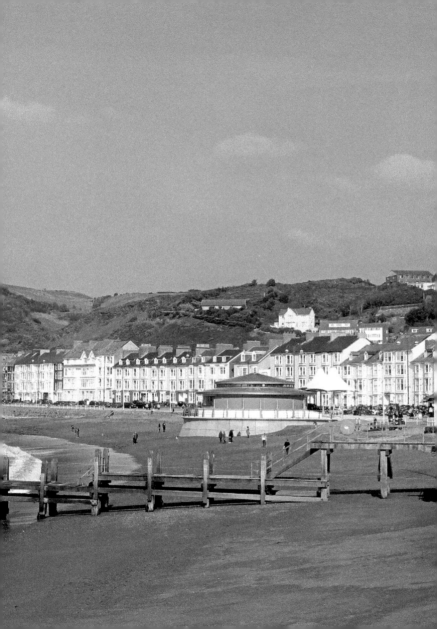

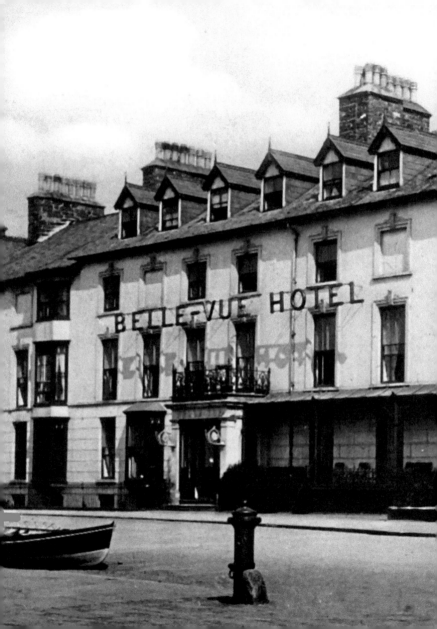

36. BELLE VUE HOTEL

The Belle Vue Hotel started life as an annex to the once popular Talbot Hotel, now The Orangery. Its guests have included film stars such as Richard Burton and Elizabeth Taylor. During the Second World War Aberystwyth was home to No. 6 Initial Training Wing of the RAF and some of their trainee pilots were billeted at the Belle Vue. Redecoration of one room in 2007 revealed graffiti by these airmen. Much of it was technical data regarding aircraft and navigation using the night sky, while some of it was more light-hearted. One Aberystwyth merchant seaman reminisced that coming home to Aberystwyth on leave: 'You couldn't get a girl 'cos the RAF had them all.'

37. LOOKING DOWN TERRACE ROAD

The ornamental windows on the right were once part of the Welsh Harp Hotel, now Libertines Cocktail Bar. The Blue Bell Hotel has also long gone. One feature that remains is the Coliseum, a music hall turned cinema that now houses the local museum and well worth a visit.

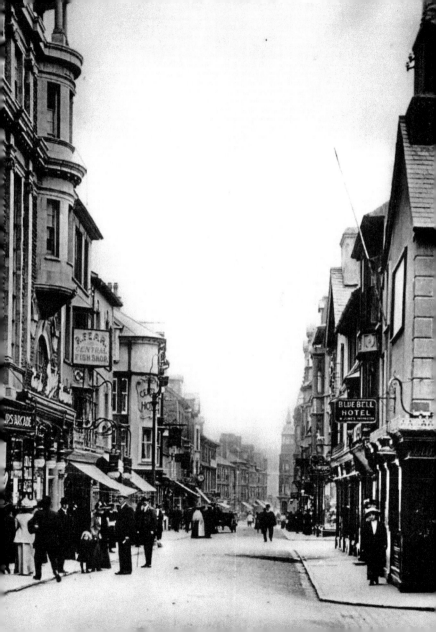

38. BANDSTAND

The bandstand here was built in 1935, the only one in Britain built to commemorate the silver jubilee of King George V. The present-day bandstand was completed in 2016 using much of the original foundations.

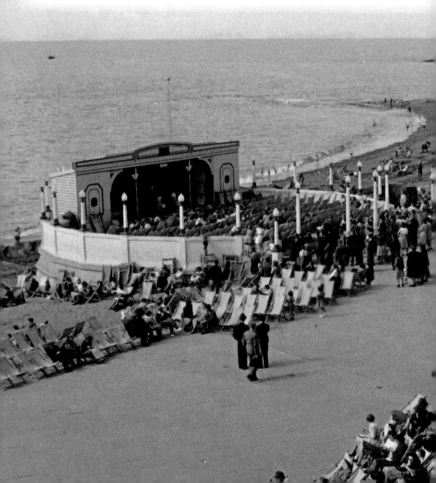

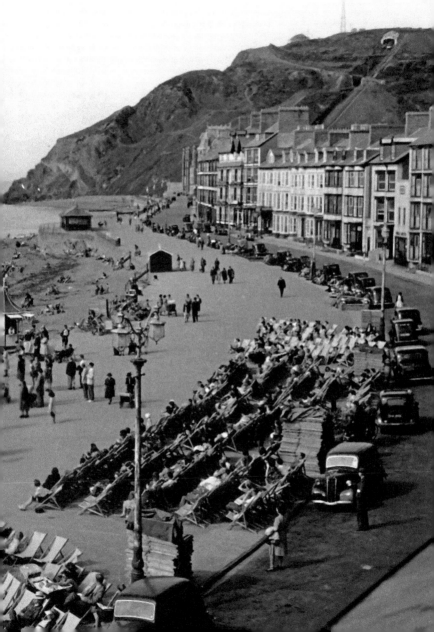

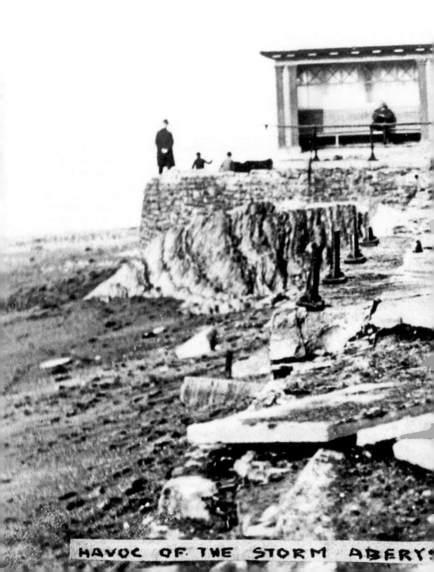

HAVOC OF THE STORM ABERY

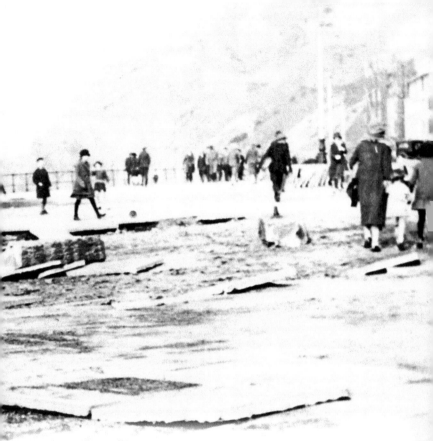

39. BATH ROCK SHELTER

The Bath Rock Shelter seen here is believed to mark the site of the town's medieval gallows. It was built in 1925 for a total cost of £365. Although it weathered this storm in 1927, during the winter storms of 2014 it was severely damaged and later rebuilt at many times its original cost.

VYTH OCT 28 1927.

40. QUEENS HOTEL

This fine building, built in the French Hotel de Ville style housed the Queens Hotel from 1866 until it's conversion to county offices circa 1950. The exterior is used as the police station in the popular television series 'Hinterland', ironic as the rear of the building once served as the town police station.

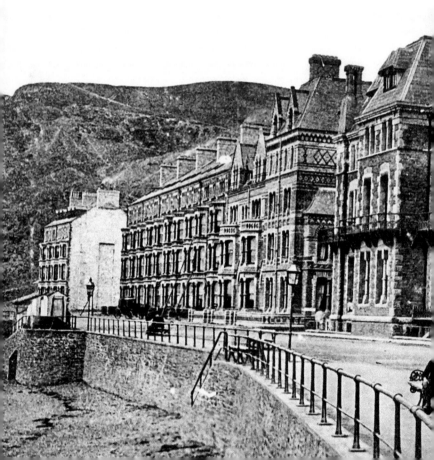

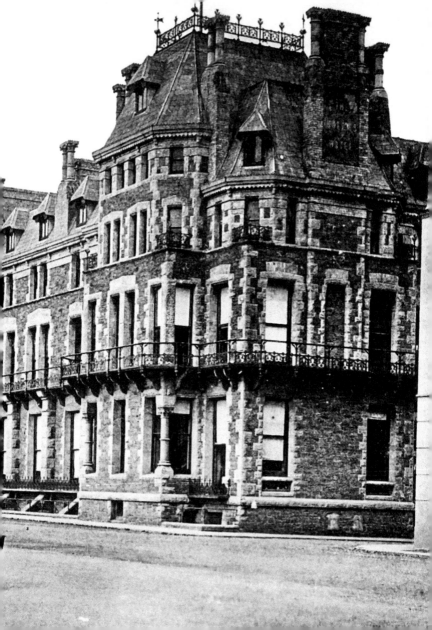

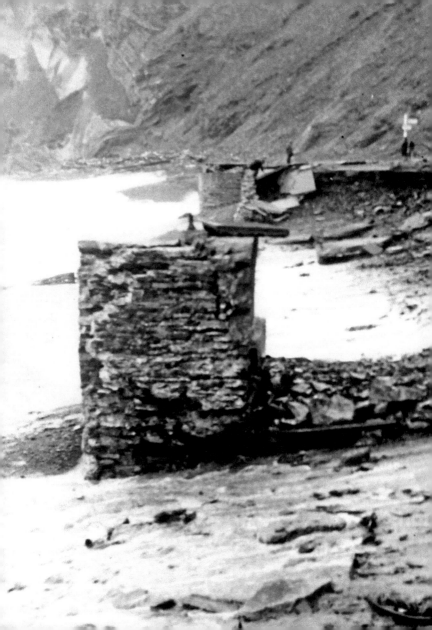

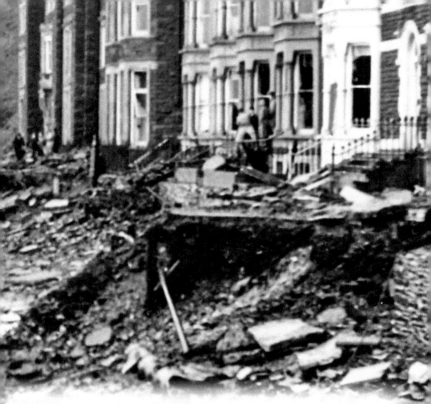

41. STORM DAMAGE, 1938

Although the storm in October 1927 caused much damage, that in January 1938 was of a far different order. Every property north of the Marine Hotel was damaged and the whole of the promenade in front of Victoria Terrace was washed away, exposing the foundations of the houses. Such was the force of the waves that water hitting the seafront was sent into the air with such vigour, and in such quantities, that it ran down chimneys and extinguished fires. Today an apron of boulders protects the seawall from a recurrence.

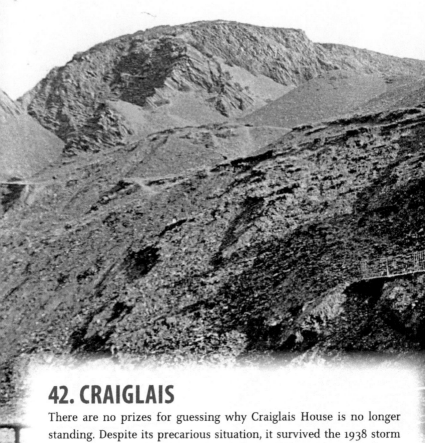

42. CRAIGLAIS

There are no prizes for guessing why Craiglais House is no longer standing. Despite its precarious situation, it survived the 1938 storm and was eventually demolished in the early 1970s. The area has since been landscaped and all traces of the house have gone. Residents and visitors from far and wide descend here to engage in the age-old tradition of kicking the bar, an old Aberystwyth custom whose origin is lost in the mists of time.

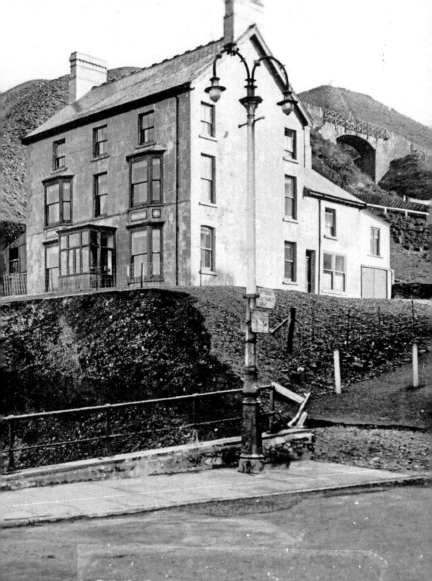

CRAIGLAIS HOUSE
ABERYSTWYTH.

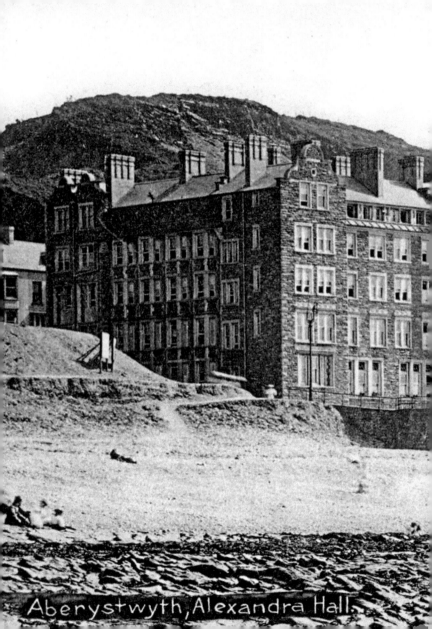

Aberystwyth, Alexandra Hall.

43. ALEXANDRA HALL

Alexandra Hall was officially opened by Princess Alexandra, wife of the future King Edward VII on 26 June 1896. Named in her honour it was one of the first university halls of residence built specifically for women students. Capable of accommodating 200 students it ceased to be a female-only hall in 1986.

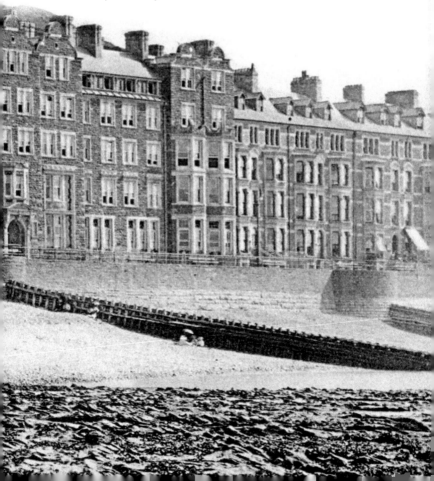

44. CLIFF RAILWAY

Aberystwyth Cliff Railway also opened in 1896. In all, 12,000 tons of rock were moved to carve out the cutting for the 778-foot-long track. Originally it was powered by a combination of water and gravity, a tank on the front of the downward carriage being filled with water to enable it to pull up its counterpart. Its stepped carriages make it unique amongst Britain's funicular railways.

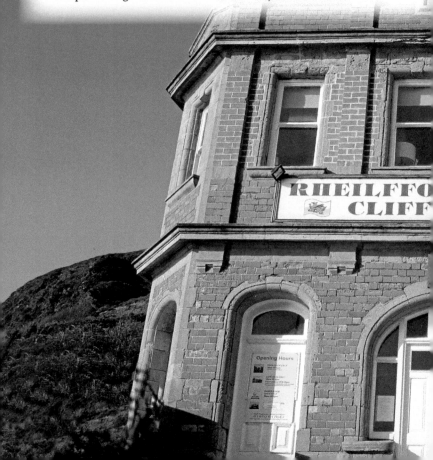

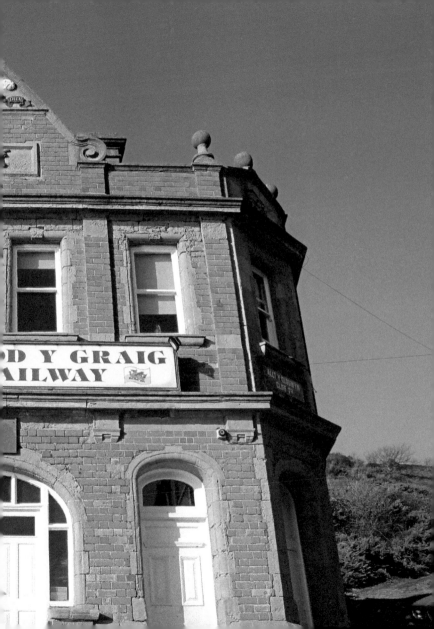

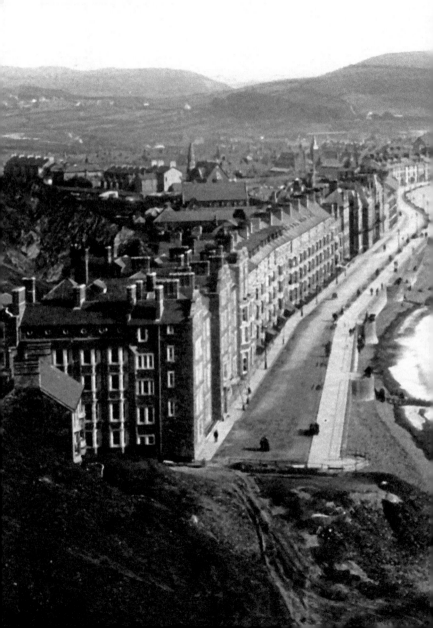

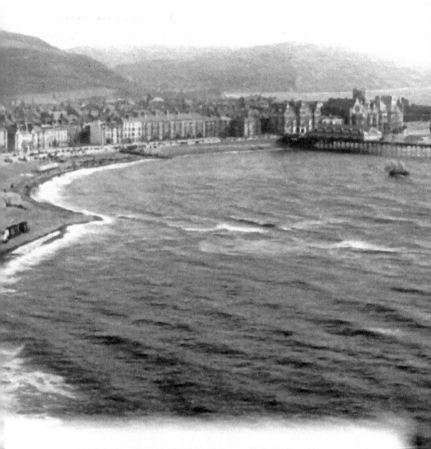

45. VIEW FROM CONSTITUTION HILL

Now you've arrived at the top of Constitution Hill. After taking in the fine view of the town and Cardigan Bay you deserve a pot of tea and a plate of Welsh cakes at Y Consti Restaurant before exploring the Camera Obscura for even more fine views.

ALSO AVAILABLE FROM
AMBERLEY PUBLISHING

Aberystwyth
– AND THE –
GREAT WAR
William Troughton

ISBN 9781 4456 4290 1
eISBN 9781 4456 4303 8